JIMMY CHOO

JIMMY CHOO
XV

New York · Paris · London · Milan

CONTENTS

Foreword
COLIN MCDOWELL
7

Preface
TAMARA MELLON, OBE
17

CHAPTER I	*Celebrity Icons*	25
CHAPTER II	*Walk on the Wild Side*	49
CHAPTER III	*Novelty and Whimsy*	71
CHAPTER IV	*Technical Innovation*	93
CHAPTER V	*Fashion Fringe*	107
CHAPTER VI	*Pace Setting*	135
CHAPTER VII	*Red Carpet Glamour*	157
CHAPTER VIII	*The Jimmy Choo Foundation*	181

Index
192

Acknowledgements
198

Foreword

COLIN MCDOWELL

Shoes have a magical, almost mythical hold on our imaginations. For centuries, fairy tales have been spun around them; they have been talismans of good luck—even today, shoes play a symbolic part in wedding ceremonies across Europe: the story of Cinderella and her dramatic change of fortunes centres on a slipper. From Puss in Boots to the power of seven-league boots, footwear has more historic references in songs and tales than any other item of dress.

So, it seems appropriate to start with a modern fairy story, beginning in the traditional way.

Once upon a time there was a shoemaker working in the East End of London. In the West End of London was a beautiful and clever young woman who specialised in accessories—and especially shoes—in her work for a very famous and glamorous magazine.

The shoemaker was Jimmy Choo; the beautiful and clever young woman is Tamara Mellon; the magazine, British Vogue. The rest is, as they say, history. But it is a tale well worth the retelling.

Tamara Mellon, OBE (Order of the British Empire), was born in London, the daughter of a highly respected business entrepreneur and a woman who used to model for Chanel. Even before her privileged education took her from England to Beverly Hills and Switzerland, it can be imagined that Tamara Yeardye, as she was in those days, would be an achiever. But it is doubtful that many could foresee that she would take a small niche business

in Hackney and turn it into a world player — and possibly THE world player — in high-octane glamour shoe design.

It was in the genes. Her entrepreneurial father—the man who co-founded the hugely successful hair-care empire of Vidal Sassoon—was both supportive and even a little demanding of Tamara, and was quite a lot to live up to.

Like him, she knew that she would succeed. In addition, she knew what it was she wanted to succeed in. Of course, it had to be shoes. Perhaps accessories later, if all went well. And, of course, as everyone knew, it couldn't fail. Shoes were Tamara's obsession. She couldn't stop buying them, so it was natural that she would want to start selling them. And, as the Vogue accessories editor, Tamara— the archetypal uptown girl—found herself increasingly at Jimmy Choo's factory in an old abandoned hospital in a very downtown area of London (since transformed into one of the city's coolest and most creative districts). In 1996, she took the plunge and with the backing of her father—not just financially but, more importantly, psychologically—she founded the Jimmy Choo business we know today. She set about learning what shoe design was all about and planning how the business could be built into something that would fulfil her ambitions which, she admits, were huge.

Huge ... but totally realisable because this was not just another story of a spoilt little rich girl being indulged by her father before she settled down in marriage and became yet another well-heeled 'yummy mummy.' Tamara knew the territory; could both talk the talk and walk the walk—and very elegantly in her Jimmy Choo shoes. Above all, she knew exactly the lifestyle her shoes would need to fit into and service. It was her own lifestyle. It was about travel, luxury experiences, glamour, and all that goes towards making what is known as the life of the super-rich. She did all the right things, in all the right places.

But it would be a mistake to assume that Tamara saw Jimmy Choo as merely the business that bankrolled a lifestyle. It was the other way around. Tamara's lifestyle serviced Jimmy Choo in that wherever she was in the fun, sun, luxury spots across the globe, she was with her customers. She knew what their lives demanded— and especially for their feet. I asked her once where she was off to next. She replied, 'Miami.' 'Have fun', I said. 'I'll try, but it's a research trip.' 'Sure', I thought. Then I thought a little more. Tamara wasn't playing games with me. She meant it. Of course it was a research trip, just like every other trip she takes, because she looks and she listens and then she measures what she has seen and heard against her antennae, which are more advanced and sensitive than anyone's. And she is doing it alongside her customers.

Then she comes back home and the process of creating the new collection begins. Tamara does not draw. She explains her ideas using what she calls the 'zeitgeist,' referencing a world of inspiration that can range from contemporary art and hip hop music to foreign films and fashion muses, where a vintage hat covered in feathers provides the spark to create a fantastical platform sandal. She talks with her creative team, and Tamara describes what she has seen on her travels. She defines the spirit she feels is the next move for Jimmy Choo. It is an exciting time, and it is at that point that the shoes that will make women's hearts skip a beat next season, will stand on the red carpets, and will be featured in full colour in Vogue, Harper's, and every glossy magazine under the sun—it is at that early point that Tamara knows exactly how they will be.

To any outsider, this business seems a classic of success, with no false starts, no mistaken moves. Just a clear trajectory to a point planned long before, a point of perfection, because that is all that Tamara will accept. Like every highly successful designer I know, the prospect of cutting corners, doing

something without thinking it through, turning a blind eye to a slight design fault or imperfection, is not an option.

And here is the reason why. It is easy to say—and I hear it often enough—that high fashion is dominated by women with so much money that they don't really care about quality. Easy, but entirely wrong. And Tamara Mellon knows that. She is perfectly aware that if people are paying for the best they expect to get the best. Every time. No matter if the bills (and we all know that quality can never be anything other than very expensive) are paid by the Jimmy Choo customer herself, by her lover, her husband, or out of the alimony, somebody somewhere along the chain is going to ask of a pair of shoes—or the madly successful handbags with the Jimmy Choo label—'Are they worth it?'

The answer is yes, of course they are. But Tamara realises that they can only remain worth it with a great deal of effort from her and her team. Shoe design is changing fast. After some years of vertiginous heels and almost as high soles, along with strappy, naked looks, a new elegance is beginning. Stilettos are returning; the scale of shoes is being pared back; ladylike is even hovering on the fashion horizon. In a few seasons' time shoes will be more aerodynamic; they will reflect architecture as seen in London's Shard and design as seen in the Dyson Airblade.

I was about to add 'and Tamara Mellon's Jimmy Choo will be part of the trend.' And then I flicked through this elegant book again and realised that it was the wrong phrase. Looking at the pictures, it is clear that she is leading the trend—and has been since 2008, her Annus Mirabilis in which she received the Designer Brand of the Year award from the British Fashion Council, the ACE Award for Brand of the Year from the Accessory Council, and the Brand of the Year from the 22nd Annual Footwear News Awards in New York, to be followed in 2009 with the Nordstrom Partners in Excellence

Award. To crown that run of success in 2010, Tamara was appointed by the Prime Minister, the Rt. Hon. David Cameron as Business Ambassador to promote trade for Britain, and OBE by Her Majesty the Queen for services to the fashion industry.

Tamara Mellon started her retail empire on home ground when she opened her first stand-alone boutique in her hometown on London's Motcomb Street, which was followed in 1998 by the first Jimmy Choo boutique in New York; then LA; then the world. Filled with shoes, women's handbags, perfume, scarves, sunglasses, and now men's shoes, there are Jimmy Choo stores around the world—and the lists of products and locations continue to grow.

Tamara once said that her dream was to capture the hearts of women, no matter where they were in the world. It can be said with total fairness that she has absolutely realised that dream in the fifteen years since founding Jimmy Choo. She has achieved unprecedented brand awareness and loyalty. But there will be no sitting back on her laurels. For people like Tamara Mellon, the fact of huge success already achieved acts as a stimulus and inspiration to achieve even more.

I have no doubt that this amazing woman will achieve all that she dreams of—and quite a lot besides—in the next fifteen years of her reign. Like all great fashion designers, Tamara Mellon has not only created a unique design vocabulary with her shoes; she has also stimulated a desire in her customers to enter a different, more exotic world: the world of Jimmy Choo. The world of Tamara.

Now, if that isn't a fairy tale ending, I don't know what is.

'I always dreamed of creating the perfect luxury accessory house, one that captures the hearts of women around the world. But even now, with everything that we have accomplished, we're far from resting on our laurels. What excites me most is the thrill of the next project, the next idea, and continuing to surprise and delight our loyal Jimmy Choo fans. And while I am enormously proud of our brand's heritage, I know that the best is yet to come.'

TAMARA MELLON, OBE
Founder and Chief Creative Officer

Preface

TAMARA MELLON, OBE

When I think of the icons that have inspired me throughout my life, they are often women. Powerful, glamorous, confident women. Cinematic and music icons such as Catherine Deneuve, Anouk Aimée, and Debbie Harry are among the many muses I have in my imagination when I am creating my collections for Jimmy Choo. These iconic beauties hold an allure that is as much about their external style as their innate sense of self-confidence. I look to modern icons as well, and in business, I think of iconic women such as Michelle Obama, Diane von Furstenberg, Tory Burch, and Natalie Massenet, whose ingenuity, cleverness, and sense of humour set them apart as role models for me and for my daughter's generation. My ambition for Jimmy Choo when I created this company was always to capture the hearts of women around the world and build it into an enduring world-class luxury brand that would inspire women everywhere.

The icons that I set out to highlight in this book take their cue from the women that inspire me in my life, but they are the shoes themselves. Around the office, we refer to the shoe styles as 'She,' endowing them with a personality, life, and story all their own. 'Glenys' is attending an art opening before she hops the Eurostar back to London. 'Macy' is headed into hair and makeup before she hits the step and repeat. 'Fleur' has a board meeting this morning followed by lunch with her banker. Amongst the thousands of shoes that have been created, each has her own story. When they are launched into the world, the women that wear the shoes add their own stories.

As these women create their stories, they have turned the Jimmy Choo shoes into icons in and of themselves. For some women, these shoes took them up the stairs of the Dorothy Chandler Pavilion to accept an Academy Award. Another was immortalized by Sex and the City's Carrie Bradshaw who 'lost her Choo'. Another pair walked up the steps of the US Capitol with Michelle Obama as her husband was sworn in as President of the United States. And yet another accompanied me to meet the Queen when I was awarded the OBE, Order of the British Empire. In reviewing the archives to select the most iconic among the thousands of shoes, the stories all came flooding back. With my design team, we reflected on these stories, and selected those that were most seminal for Jimmy Choo—those that became legends because of the iconic women who wore them, those whose design launched a signature Choo style, and those who, for sentimental reasons, walked with me through a memorable moment of my life.

Each of the fifteen shoes in Jimmy Choo XV is accompanied by a set of images that serves to narrate its place in our history. The red carpet moments, the gorgeous editorials that have appeared in the world's most famous fashion magazines, the Jimmy Choo advertisements lensed by some of the most brilliant photographers, and the personal photos from my archives, all create an anthology of Jimmy Choo over the years. In regarding these shoes, these images, and the women that wear them, a theme emerges: Jimmy Choo makes women feel powerful.

This theme of female empowerment is one that reveals itself to me as an entrepreneur, as a mother, and as a visionary for the Jimmy Choo brand. It is also what has motivated me to create a charitable foundation—the Jimmy Choo Foundation—a charitable trust that is devoted to empowering women by helping them and others to lead healthier and safer lives. I feel extremely lucky to have been born into a world where I had access to good

healthcare, and was free from the threat of persecution; I want to help women to feel safe and healthy, so they can feel strong and confident.

In years past, we have partnered with the Elton John AIDS Foundation to raise funds for the Simelela Rape Centre in South Africa. In another initiative we developed an exclusive product collection called Project PEP— a portion of the proceeds from the collection's sales went to fund the administering of HIV preventative PEP medication. In total, Jimmy Choo was able to raise more than $3.5 million and treat more than a half million women in Africa affected by HIV.

Jimmy Choo XV marks the first step in a long-term commitment to the Jimmy Choo Foundation. One hundred percent of the Jimmy Choo proceeds from the sale of this book will benefit the Jimmy Choo Foundation; it is the first of what I am sure will be many fundraising initiatives.

CHAPTER

Celebrity Icons

Ever since the shoes first strutted along the red carpet, Jimmy Choo has been in demand. As its status as an awards show regular became further entrenched, celebrities began to look to Jimmy Choo for other high-style moments. The brand soon became a go-to resource for red carpet dressing, high profile premieres, and magazine photo shoots. Fashion's rise as a source of pop culture fascination helped to fuel the interest in celebrity style until every element of a star's wardrobe became a source of inspiration. Jimmy Choo shoes became identified almost as much by who wore them, as for the styles themselves.

The brand's mythology as a celebrity resource was confirmed when Jimmy Choo was integrated into the script for Sex and the City, the ultimate vehicle for fashion via television. Sarah Jessica Parker's character, Carrie, has a Cinderella moment when she anguishes exclaiming, 'I've lost my Choo!'

FEATHER
Spring/Summer 1998

'I lost my Choo!'

CARRIE BRADSHAW
running to catch the Staten Island Ferry in Sex and the City, 2000.

Shontelle 'T-shirt' music video, as she sings about Jimmy Choo, 2008

MACY
Spring/Summer 2004

'Macy has always been one of our most treasured red carpet styles and has become something of a good luck charm for Oscar nominees. Natalie Portman was wearing Macy when she won her award for best actress.'

TAMARA MELLON, OBE

Whitney Houston
'My Love is Your Love'
album cover, 1998

CHAPTER

Walk on the Wild Side

The allure of Jimmy Choo is owed as much to its fashionable celebrity fans as to the brand's ability to telegraph a unique blend of female power, glamour, and sex appeal. Early on, the use of bold animal prints helped to imbue its wearers with a sense of luxury and power. Leopard, zebra, and exotic skins such as python and crocodile conveyed a woman's ultimate confidence and femininity.

Iconic uses of exotic prints were creatively reimagined in painterly colours, extended into thigh-high boots, twisted into sandals, and sculpted into handbags. The interplay of wild animal prints and exotics within the product design is now an integral part of the Jimmy Choo visual vocabulary.

Fifth Avenue

CARLY
Autumn/Winter 1999

'Animal prints quickly became synonymous with the Jimmy Choo woman. Carly in bold zebra print was designed to celebrate the opening of our first USA store in NYC. It was a graphic city statement.'

TAMARA MELLON, OBE

FERRARI
Autumn/Winter 2000

'We developed this unique python skin with a special "night" degradé effect; it's slightly wicked.'

TAMARA MELLON, OBE

GLENYS

Autumn / Winter 2008

'Tamara has developed a distinct language, whether it's the heels or the straps or the slightly rock 'n' roll attitude mixed with the ladylike.'

NATALIE MASSENET
Founder & Executive Chairman, Net-A-Porter

CHAPTER

Novelty and Whimsy

The bold confidence of Jimmy Choo designs is not limited to the realm of animal prints and exotics. The Jimmy Choo woman also communicates her sense of spirit and creativity through her shoes. Novelty prints such as gingham, denim, and Broderie Anglaise combine with whimsical embellishments. Coloured gems, silk corsages, and seashells show the playful side of the brand.

Experimental prints incorporating graffiti, punk rock iconography, and art also have made their way into the Jimmy Choo collection. Pioneering artistic collaborations fuelled the development of limited edition novelty product such as the clutch bags created from a graphic image by artist Richard Phillips.

Fine artist Richard Phillips's 'Riot' (PREVIOUS SPREAD) and 'Nuclear' (OPPOSITE) were used by Jimmy Choo on clutch bags in Spring/Summer 2008

MONTE

Spring/Summer 2001

'With a daring dose of print and gemstones, Monte takes me poolside to the Beverly Hills Hotel, where she first made her debut.'

TAMARA MELLON, OBE

MURIAL
Spring/Summer 2001

'I've always loved flowers, and Murial was a chance to explore the shoe as a canvas for creativity, embellishing the foot with a glittery corsage.'

TAMARA MELLON, OBE

MARY
Spring/Summer 2001

*'The Jimmy Choo woman
is serious in her love of fashion,
but lives with a certain style of
humour and wit in her approach.
It's what sets her apart.'*

RAUL MARTINEZ

Design Director, American Vogue

JIMMY CHOO

CHAPTER

Technical Innovation

For Jimmy Choo, the shoe is not only an extension of a woman's sense of style, but also a means to communicate the power of her ingenuity and limitless possibilities. Futuristic design flourishes such as Lucite, Perspex, and glitter, or even luminescence, are incorporated into the shoe design to reference the feminine ideal of a heroine in command of her destiny.

Nowhere was this display of technical innovation more evident than in the creation of the Zap shoe, a strappy sandal with a clear Lucite heel illuminated in a flash of neon light.

NIAGRA

Cruise 2011

'Kicking off our 15th anniversary year, Niagra combines technology and glamour with a jewelled Perspex upper, Plexi platform, and heel infused with rock crystal glitter.'

TAMARA MELLON, OBE

ZAP
Spring/Summer 2010

'Zap is a reflection of the innovation and limitless imagination of our design team, with a Lucite platform heel that lights up as you walk.'

TAMARA MELLON, OBE

CHAPTER

Fashion Fringe

An editorial favourite, Jimmy Choo has always been at the forefront of fashion innovation. A portion of each seasonal collection is designed to celebrate the extreme creativity of the design and set the ultimate reference point for fashion.

Seasonal fashion is explored to almost fantasy lengths: lace-up sandals scaling up the thigh, boho fringe spiralling in layers, raffia woven with glossy patent leather into mosaic patterns, vivid colour blocking on heel and uppers.

FRINGE

Spring/Summer 2002

*'The Jimmy Choo woman
is in command of her femininity.
We always try to capture that sense
of power in our photos.'*

INEZ VAN LAMSWEERDE & VINOODH MATADIN

CHAPTER

Pace Setting

From the boardroom to the ballroom, from the jetway to the runway, Tamara Mellon referenced her busy life and that of her friends when creating the collections. With an entrepreneur's spirit stewarding the brand, it's no wonder that women leaders from CEOs to heads of state have chosen Jimmy Choo to take them through their daily paces. The Jimmy Choo stiletto has, in fact, given permission to women to express the full authority of their femininity and declare it as an integral part of their power and confidence.

Tamara Mellon receiving her OBE (Order of the British Empire) 2010

FLEUR

Autumn / Winter 2010

'I chose to wear Fleur to collect my OBE as it's the ultimate shoe for ladylike dressing. For me, this shoe encapsulates the femininity and sophistication of the Jimmy Choo woman, combining snakeskin print, lace, and patent detailing.'

TAMARA MELLON, OBE

CHAPTER

Red Carpet Glamour

The Jimmy Choo iconography may be best expressed in its moments under the glare of the paparazzi's flash. A pioneer in the art of celebrity dressing, Tamara Mellon was among the first to draw the focus to the foot, where she shod her celebrity muses in the most glamorous Jimmy Choo creations. The red carpet proved to be the ideal runway for shoes and then handbags, as women proudly responded 'Jimmy Choo' when asked, 'What are you wearing?'

Referencing classic Hollywood glamour in materials such as satin and crystals, the Jimmy Choo artisans incorporate design innovations that allow the shoes to command an attention all their own. Satin platform sandals that can be dyed in the richest fashion colours, genuine diamonds cascading around the ankle like foot jewellery, and built-in platforms that allow heels to climb ever higher, all add to the brand's dizzying allure.

Hilary Swank
Screen Actors Guild Awards, 2005

Keira Knightly
63rd Annual Golden Globes Awards, 2006

Sandra Bullock
82nd Annual Academy Awards, 2010

Meryl Streep
82nd Annual Academy Awards, 2010

Leighton Meester
68th Annual Golden Globes Awards, 2011

ZAFFIRA
Cruise 2011

'Zaffira was very much a reflection of my personal style—a little glamour, a little rock and roll—
and has been a red carpet regular for girls who have a bit of an edge to their style.'

TAMARA MELLON, OBE

BAMBI
Spring/Summer 1999

'The Diamond Bambi was a bespoke one-off creation made with real diamonds, designed for the 1999 Academy Awards. I was inspired by the glamorous jewels worn on the red carpet and loved the idea of creating jewellery for the feet.'

TAMARA MELLON, OBE

Sienna Miller
Venice Film Festival, 2005

Zoe Saldana
amfAR New York Gala, 2010

Taylor Swift
Vanity Fair Oscar Party, 2011

Helen Mirren
79th Annual Academy Awards, 2007

Diane Kruger
Sidaction Gala Dinner, 2011

Rihanna
52nd Annual GRAMMY Awards, 2010

LANCE
Cruise 2009

'Jimmy Choo is synonymous with celebrity dressing and no other shoe has walked the red carpet more than Lance. This iconic strappy sandal has become a favourite worn by celebrities around the world.'

TAMARA MELLON, OBE

Jennifer Aniston
Film Premiere, London, 2010

Uma Thurman
Cannes Film Festival, 2011

Tamara Mellon & Usher
The Metropolitan Museum of Art Costume Institute Gala, 2010

V

CHAPTER

The Jimmy Choo Foundation

Since the company's inception, Tamara Mellon has used her voice and position with Jimmy Choo to speak out on behalf of women's issues and support charitable endeavours that address the needs of women and children. In 2005, the company partnered with the Elton John AIDS Foundation to raise funds for the Simelela Rape Centre in South Africa. In a bold fundraising effort, Tamara Mellon tapped inspiring women and asked them to sit for eminent female fashion photographers and pose wearing nothing but Jimmy Choo shoes and Cartier jewellery. These photos were auctioned off for a project called '4 Inches' and the proceeds were used to provide initial funding for Simelela.

Four years later, the company launched a limited edition collection of shoes and bags in a signature punk print, and sold this capsule collection as Project PEP, again supporting the Elton John AIDS Foundation. Twenty-five percent of net sales from this collection were donated to the Simelela Rape Centre to fund the administering of HIV preventative PEP medication. Between these initiatives, more than $3.5 million has been raised by Jimmy Choo to support women in Africa affected by HIV.

In 2011, the company launched the Jimmy Choo Foundation, a charitable initiative to support the ideals of the founder who is dedicated to 'empowering women and allowing them to live their fullest life possible'.

(OPPOSITE PAGE)
Tamara Mellon, OBE with her daughter Minty for the launch of the Project PEP collection in New York, 2009

Kate Moss and Elle Macpherson in '4 Inches', a book featuring images from the world's most respected female photographers of inspiring women wearing nothing but four-inch Jimmy Choo heels and Cartier jewellery, 2005

Tamara Mellon, OBE visits India, 2005.

Tamara Mellon, OBE, visits the Ikamva Labantu Multi-purpose Rainbow Centre in Gugulethu Township, Cape Town, 2010.

Tamara Mellon, OBE, receives
an Enduring Vision Award from the
Elton John AIDS Foudation, 2010

'Tamara Mellon is the rare philanthropist who commits herself heart and soul to a project. She has proven to be a stalwart ally to the Elton John AIDS Foundation.'

SIR ELTON JOHN

Tamara Mellon, OBE, Sir Elton
John and David Furnish, White Tie
& Tiara Ball, 2009

Index

Vanity Fair US, August 2005, Tamara & Minty Mellon, PHOTO: Francois Halard / trunkarchive.com

Tamara Mellon, PHOTO: Sean Thomas

Tamara Mellon, PHOTO: Uli Weber / Getty Images

Tamara Mellon, PHOTO: Douglas Friedman / trunkarchive.com

Tamara Mellon, PHOTO: Wireimage / REX

CHAPTER I
Celebrity Icons

Vogue UK Celebrity Style Supplement, November 2000, PHOTO: Paul Zak / *Vogue* © The Condé Nast Publications Ltd

Marie Claire UK, March 2007, Hilary Swank, PHOTO: Richard Bailey

Elle US, December 2009, Sarah Jessica Parker, PHOTO: Alexei Hay

Sarah Jessica Parker as Carrie Bradshaw in *Sex and the City*, 2000, Photo Courtesy of Home Box Office

Footage from the Shontelle *T-Shirt* music video used by permission of SRC/Universal Records, a division of UMG Recordings, Inc.

Harper's Bazaar UK, August 2006, Kate Bosworth, PHOTO: Norman Jean Roy

ADVERTISING CAMPAIGN: Spring / Summer 2004, Louise Pederson, PHOTO: David Slijper

InStyle UK, April 2009, Rosamund Pike, PHOTO: Frederic Auerbach

i-D, June 2008, Mariah Carey, PHOTO: Vincent Peters

ADVERTISING CAMPAIGN: 1998, PHOTO: Matthew Donaldson / trunkarchive.com

Whitney Houston *My Love Is Your Love* Album Cover, Whitney Houston, PHOTO: Dana Lixenberg, Courtesy of Nippy, Inc.

Tatler UK, May 2010, Heidi Klum, PHOTO: Rankin / trunkarchive.com

ADVERTISING CAMPAIGN: Spring / Summer 2006, Nicole Richie, PHOTO: Brett Ratner

CHAPTER II
*Walk on
The Wild Side*

ADVERTISING CAMPAIGN:
Spring / Summer 2006, Nicole Richie, PHOTO: Brett Ratner

ADVERTISING CAMPAIGN:
Spring / Summer 2006, Nicole Richie, PHOTO: Brett Ratner

ADVERTISING CAMPAIGN:
Spring / Summer 2008, Angela Lindvall, PHOTO: Terry Richardson

ADVERTISING CAMPAIGN:
Spring / Summer 2005, Marina Perez, PHOTO: Mario Testino

Vogue UK, September 2009, PHOTO: Mark Mattock / *Vogue* © The Condé Nast Publications Ltd

Marie Claire US, March 2009, Tatyana Usova, PHOTO: Jonty Davies

ADVERTISING CAMPAIGN:
Cruise 2007, Natalia Oviedo, PHOTO: Raymond Meier

Harper's Bazaar US, August 1999, PHOTO: Greg Delves

ADVERTISING CAMPAIGN:
Autumn / Winter 2005, Anja Rubik, PHOTO: Mario Testino

ADVERTISING CAMPAIGN:
Autumn / Winter 2008, PHOTO: Terry Richardson

Pop, March 2010, PHOTO: Marilyn Minter

Numero France, September 2009, Eva Herzigova, PHOTO: Miguel Reveriego / trunkarchive.com

ADVERTISING CAMPAIGN:
Spring / Summer 2008, Anouck Lepere, PHOTO: Lachlan Bailey

Marie Claire France, April 2008, PHOTO: Peter Lippmann

CHAPTER III
Novelty and Whimsy

Riot, 1998, Oil on Linen, 90 x 127 inches, 228.6 x 322.6 cm, Courtesy of Richard Phillips Studio

Cosmopolitan España, April 2008, Alice Rausch, PHOTO: Enric Galcernan

Nuclear, 1997, Oil on Linen, 84 x 60 inches, 213.4 x 152.4 cm, Courtesy of Richard Phillips Studio

Madame Figaro France, July 2009, PHOTO: © Gyslain Yarhi / *Madame Figaro*

Index

ADVERTISING CAMPAIGN:
Spring / Summer 2003, Guinevere Van Seenus, PHOTO: David Slijper / trunkarchive.com

Backstage at the Spring / Summer 2000 Advertising Campaign, PHOTO: Sandra Choi

Spring / Summer 2010, PHOTO: Sean Thomas

Yo Dona España, November 2008, Rassmus Salomonsson & Katinka, PHOTO: Pedro Vikingo

Vogue UK, June 2008, Angela Lindvall, PHOTO: Regan Cameron / Art + Commerce

Vogue UK, February 2006, Diana Dondoe, PHOTO: Thomas Schenk / *Vogue* © The Condé Nast Publications Ltd

Vogue UK, June 2011, Dree Hemingway, PHOTO: Tom Craig / *Vogue* © The Condé Nast Publications Ltd

ADVERTISING CAMPAIGN:
Autumn / Winter 2008, PHOTO: Terry Richardson

CHAPTER IV
Technical Innovation

Crystal Collection Cruise 2011, PHOTO: Marilyn Minter

Crystal Collection Cruise 2011, PHOTO: Marilyn Minter

Crystal Collection Cruise 2011, PHOTO: Marilyn Minter

Harper's Bazaar España, December 2010, PHOTO: Jorge Crooke for Estudio La Luna

Vogue UK, February 2010, PHOTO: Raymond Meier / *Vogue* © The Condé Nast Publications Ltd

ADVERTISING CAMPAIGN:
Spring / Summer 2010, Angela Lindvall, PHOTO: Terry Richardson

Vogue US, December 2010, PHOTO: Raymond Meier / Condé Nast Archive. Copyright © Condé Nast

CHAPTER V
Fashion Fringe

ADVERTISING CAMPAIGN:
Autumn / Winter 2008, PHOTO: Terry Richardson

ADVERTISING CAMPAIGN: Autumn / Winter 2009, Angela Lindvall, PHOTO: Terry Richardson

ADVERTISING CAMPAIGN: Autumn / Winter 2008, PHOTO: Terry Richardson

ADVERTISING CAMPAIGN: Autumn / Winter 2010, Amber Valletta, PHOTO: Inez Van Lamsweerde & Vinoodh Matadin

Madame Figaro France, March 2010, Alina, PHOTO: Serge Barbeau / *Madame Figaro*

ADVERTISING CAMPAIGN: Spring / Summer 2007, Jessica Miller, PHOTO: Brett Ratner

ADVERTISING CAMPAIGN: Spring / Summer 2009, PHOTO: Terry Richardson

ADVERTISING CAMPAIGN: Spring / Summer 2011, Crystal Renn, PHOTO: Inez Van Lamsweerde & Vinoodh Matadin

ADVERTISING CAMPAIGN: Spring / Summer 2011, Crystal Renn, PHOTO: Inez Van Lamsweerde & Vinoodh Matadin

Glamour UK, August 2010, Jessica Biel, PHOTO: Norman Jean Roy

Marie Claire Italia, March 2011, PHOTO: Carlton Davis / CLM courtesy *Marie Claire* Italia

Vogue Hommes International, Lane Carlson, PHOTO: Terry Richardson

Madame Figaro France, August 2009, Hannah Cripps, PHOTO: Philippe Biancotto / *Madame Figaro*

ADVERTISING CAMPAIGN: Autumn / Winter 2011, Raquel Zimmermann, PHOTO: Steven Meisel

ADVERTISING CAMPAIGN: Autumn / Winter 2011, Raquel Zimmermann & Ben Hill, PHOTO: Steven Meisel

CHAPTER VI
Pace Setting

Arena, September 2008, Gisele Bündchen, PHOTO: Nino Munoz

Tamara Mellon receives her OBE (Officer of the Order of the British Empire) from Queen Elizabeth at Buckingham Palace, 20th October 2010, PHOTO: Getty Images

W Magazine US, March 2011, Natasha Poly & Mariacarla Boscono, PHOTO: Willy Vanderperre / Condé Nast Archive. Copyright © Condé Nast

Index

Elle UK, 2007, Reese Witherspoon, PHOTO: Gilles Bensimon

W Magazine US, March 2011, Mariacarla Boscono, PHOTO: Willy Vanderperre/ Condé Nast Archive. Copyright © Condé Nast. Publications Ltd.

ADVERTISING CAMPAIGN: Autumn / Winter 2004, Natasha Poly, PHOTO: Mario Testino

ADVERTISING CAMPAIGN: Autumn / Winter 2006, Molly Sims & Quincy Jones, PHOTO: Brett Ratner

ADVERTISING CAMPAIGN: Autumn / Winter 2006, Molly Sims & Quincy Jones, PHOTO: Brett Ratner

ADVERTISING CAMPAIGN: Autumn / Winter 2001, PHOTO: Raymond Meier

ADVERTISING CAMPAIGN: Autumn / Winter 2007, PHOTO: Brett Ratner

Vogue España, October 2010, Elena Melnik, PHOTO: Victor Demarchelier

ADVERTISING CAMPAIGN: Choo 24:7 Bags, Spring / Summer 2011, PHOTO: Max Farago

ADVERTISING CAMPAIGN: Choo 24:7 Boots, Autumn / Winter 2010, PHOTO: Sean Thomas

Vogue UK, October 2010, Lily Donaldson, PHOTO: Paul Wetherell / *Vogue* © The Condé Nast Publications Ltd

Vogue UK, November 2010, Dree Hemingway, PHOTO: Alasdair McLellan / trunkarchive.com

CHAPTER VII
Red Carpet Glamour

ADVERTISING CAMPAIGN: Spring / Summer 2009, Angela Lindvall, PHOTO: Terry Richardson

Hilary Swank, Screen Actors Guild Awards, 2005, PHOTO: Getty Images

Keira Knightley, 63rd Annual Golden Globes Awards®, 2006, PHOTO: Getty Images / Wireimage

Sandra Bullock, 82nd Annual Academy Awards®, 2010, PHOTO: Getty Images

Meryl Streep, 82nd Annual Academy Awards®, 2010, PHOTO: Wireimage

Leighton Meester, 68th Annual Golden Globes Awards®, 2011, PHOTO: Getty Images

Sienna Miller, Venice Film Festival, 2005, PHOTO: Wireimage

Zoe Saldana, amfAR New York Gala, 2010, PHOTO: Getty Images

Taylor Swift, *Vanity Fair* Oscar® Party, 2011, PHOTO: Getty Images

Helen Mirren, 79th Annual Academy Awards®, 2007, PHOTO: Getty Images

Diane Kruger, Sidaction Gala Dinner, 2011, PHOTO: Getty Images

Rihanna, 52nd Annual GRAMMY Awards®, 2010, PHOTO: Getty Images

CHAPTER VIII
The Jimmy Choo Foundation

Jennifer Aniston, film premiere, London, 2010, PHOTO: Getty Images

Uma Thurman, Cannes Film Festival, 2011, PHOTO: Wireimage

Tamara Mellon & Usher, Metropolitan Museum of Art Costume Institute Gala, 2010, PHOTO: Getty Images

ADVERTISING CAMPAIGN: Autumn / Winter 2008, Angela Lindvall, PHOTO: Terry Richardson

Tamara & Minty Mellon, Project PEP Cruise 2010, PHOTO: Deborah Anderson

ADVERTISING CAMPAIGN: Project PEP, Cruise 2010, Angela Lindvall, PHOTO: Terry Richardson

4 Inches, June 2005, Kate Moss, PHOTO: Sam Taylor-Wood

4 Inches, June 2005, Elle Macpherson, PHOTO: Ellen Von Unwerth

PHOTO: Grada Djeri, Courtesy of the Elton John AIDS Foundation

PHOTO: Sandra Choi.

Tamara Mellon, OBE, receives an Enduring Vision Award from the Elton John AIDS Foundation, 2010, PHOTO: Getty Images

Tamara Mellon, OBE, Sir Elton John & David Furnish, White Tie and Tiara Ball 2009, PHOTO: Getty Images

Acknowledgements

Thank you to Tamara Mellon for her creative vision and for being the ultimate Jimmy Choo icon.

Thank you to Colin McDowell for his inimitable writing and Nobi Koshiwagi for his inspired design.

Special thanks to Patricia Field who made Carrie Bradshaw, and in turn Jimmy Choo, a fashion legend; Marilyn Minter who made Jimmy Choo art; and all of the photographers and creative partners who bring the Jimmy Choo woman to life: Inez van Lamsweerde and Vinoodh Matadin, Raymond Meier, Steven Meisel, Brett Ratner, Terry Richardson, Mario Testino, Raul Martinez, AR New York, and Charlotte Pilcher.

Jimmy Choo would like to thank all the individuals who appear in this book including those whom we were unable to contact.

Thanks to everyone from the Jimmy Choo and Rizzoli teams, including Joshua Schulman, Sandra Choi, Simon Holloway, Elisabeth Guers-Neyraud, Dana Gers, Alex Selway-Swift, Amelia Humfress, Anthony Petrillose, and Charles Miers, who helped make this book possible.

And, thanks to the Jimmy Choo fans around the world who inspire us.

First published in the United States of America
by Rizzoli International Publications, Inc.
300 Park Avenue South, New York, NY 10010
www.rizzoliusa.com

All rights reserved. No part of this publication may be reproduced, stored in a retrieval system, or transmitted in any form or by any means, electronic, mechanical, photocopying, recording, or otherwise, without prior consent of the publishers.

JIMMY CHOO XV

Copyright © Jimmy Choo 2011

Design by Nobi Kashiwagi — Endash Space

Printed in Italy

2011 2012 2013 2014 2015 / 10 9 8 7 6 5 4 3 2 1
Library of Congress Control Number: 2011933800
ISBN: 978-0-8478-3748-9